THE

SPIRIT

OF

HAIDA

GWAII

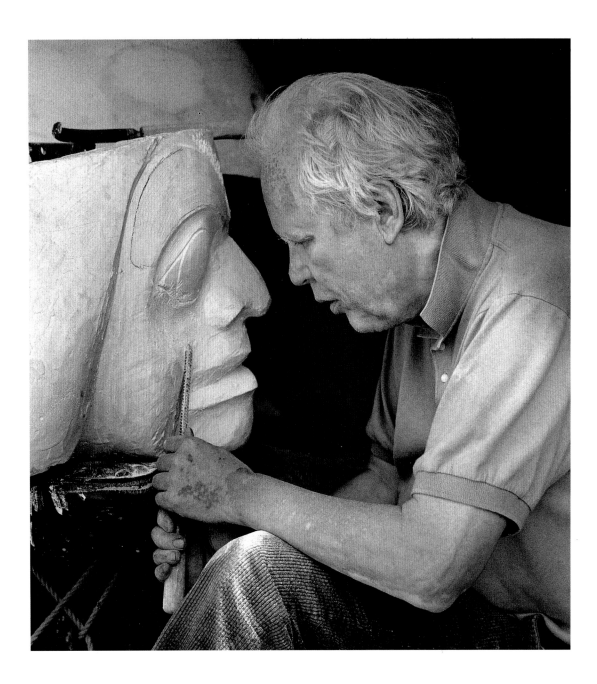

# The Spirit of Haida Gwaii

## BILL REID'S MASTERPIECE

Ulli Steltzer

Foreword by Bill Reid

Introduction by Robin Laurence

DOUGLAS & McINTYRE, VANCOUVER/TORONTO

06 07 08 09 10   6 5 4 3 2

Douglas & McIntyre Ltd.
2323 Quebec Street, Suite 201
Vancouver, British Columbia
Canada V5T 4S7
www.douglas-mcintyre.com

Library and Archives Canada
Cataloguing in Publication
Steltzer, Ulli, 1923–
The Spirit of Haida Gwaii
  ISBN-13:978-1-55054-579-1
  ISBN-10: 1-55054-579-5

1. Reid, Bill, 1920–  Spirit of Haida Gwaii.   2. Haida sculpture. 3. Haida mythology.   4. Indian sculpture—British Columbia. 5. Indian mythology—British Columbia.   I. Title.
NB249.R44S73   1997
730'.92   C96-910846-C

Library of Congress information is available upon request.

Editing by Saeko Usukawa
Design by Val Speidel
Cover photograph of *The Spirit of Haida Gwaii: The Jade Canoe* by Bill MacLennan
Printed and bound in Singapore by CS Graphics Ltd.
Printed on acid-free paper
Distributed in the U.S. by Publishers Group West

We gratefully acknowledge the financial support of the Canada Council for the Arts, the British Columbia Arts Council, and the Government of Canada through the Book Publishing Industry Development Program (BPIDP) for our publishing activities.

# CONTENTS

*by Ulli Steltzer*

T HE MAGNETISM emanating from Bill Reid's studio on Granville Island during the four years of creating the canoe with its spirit creatures was felt by many of us. It was magical. As I continued to visit Bill and the evolving sculpture, I could not help but take many pictures.

A crew of young artists and craftsmen helped Bill with the structural, technical and physical work, as well as with the defining and redefining of details and forms. I want to thank all those involved for their most generous support of my work while I was often interrupting theirs, by dedicating this little book to them:

Nancy Brignall
Jack Carson
Mike Edwards
Wade Harvey
Jim Kew
John Nutter
Rosa Quintana
Bonnie Spence
James Watt
Doug Zilkie
and especially to George Rammell
and, of course, most of all to Bill Reid

*by Bill Reid*

HERE WE ARE at last, a long way from Haida Gwaii, not too sure where we are or where we're going, still squabbling and vying for position in the boat, but somehow managing to appear to be heading in some direction; at least the paddles are together, and the man in the middle seems to have some vision of what is to come.

As for the rest, they are superficially more or less what they always were, symbols of another time when the Haidas, all ten thousands of them, knew they were the greatest of all nations.

The Bear, as he sits in the bow of the boat, broad back deflecting any unfamiliar, novel or interesting sensation, eyes firmly and forever fixed on the past, tries to believe that things are still as they were. The Bear Mother, being human, is looking over his shoulders into the future, concerned more with her children than with her legend. After all, they wandered in from another myth, the one about Good Bear and Bad Bear and how they changed, so she has to keep a sharp eye on them.

Next, doughtily paddling away, hardworking if not very imaginative, the compulsory Canadian content, big teeth and scaly tail, perfectly designed for cutting down trees and damming rivers.

And here she is, still the ranking woman of noble birth, yielding no place to the pretty Bear Mother. In spite of her great cheeks like monstrous scars, her headdress reflecting the pointed shape of the dogfish head, and her grotesque labret; in spite of all these, the most desirable and fascinating woman from myth-time. More magical than the Mouse Woman, as mysterious as the deep ocean waters which support the sleek, sinuous fish from whom she

derives her power, she stands aloof from the rest, the enormous concentration of her thoughts smouldering smoke dreams behind her inward-looking eyes.

Tucked away in the stern of the boat, still ruled by the same obsession to stay concealed in the night shadows and lightless caves and other pockets of darkness, in which she spends her immortality, the Mouse Woman lost her place among the other characters of her own myth, an important part of the Bear Mother story, and barely squeezed in at the opposite end of the boat, under the tail of the Raven. No human, beast or monster has yet seen her in the flesh, so she may or may not look like this.

Not so the Raven. There is no doubt what he looks like in this myth-image, exactly the same as he is in his multiple existences as the familiar carrion bird of the northern latitude of the earth. Of course he is the steersman. So, although the boat appears to be heading in a purposeful direction, it can arrive anywhere the Raven's latest whim dictates.

A culture will be remembered for its warriors, philosophers, artists, heroes and heroines of all callings, but in order to survive it needs survivors. And here is our professional survivor, the Ancient Reluctant Conscript, present if seldom noticed in all the turbulent histories of men on earth. When our latter-day kings and captains have joined their forebears, he will still be carrying on, stoically obeying orders and performing tasks allotted him. But only up to a point; it is also he who finally says "Enough," and after the rulers have disappeared into the morass of their own excesses, it is he who builds on the rubble and once more gets the whole thing going.

The Wolf to the Haidas was a completely imaginary creature, perhaps existing over there on the mainland, but never seen on Haida Gwaii. Nonetheless, he was an important figure in the crest hierarchy. Troublesome, volatile, ferociously playful, he can usually be found with his sharp fangs embedded in someone's anatomy. Here he is vigorously chewing on the Eagle's wing while that proud, imperial, somewhat pompous bird retaliates by attacking the Bear's paws.

That accounts for everybody except the Frog who sits partially in and partially out of the boat below and above the gunwales: the ever-present intermediary between two of the worlds of the Haidas, the land and the sea.

So there is certainly no lack of activity in our little boat, but is there any purpose? Is the tall figure who may or may not be the Spirit of Haida Gwaii leading us, for we are all in the same boat, to a sheltered beach beyond the rim of the world as he seems to be, or is he lost in a dream of his own dreamings? The boat goes on, forever anchored in the same place.

# INTRODUCTION

*by Robin Laurence*

A T ANY TIME of the day or night, in any condition of
wakefulness or jet lag, excitement or fatigue, travellers
through the Vancouver International Airport can be found gaz-
ing at Bill Reid's monumental and complex bronze sculpture,
*The Spirit of Haida Gwaii*. As they dash or saunter between
flights, clutching bags and boarding passes, they are caught up
by the sight of this other group of travellers—thirteen of them,
drawn from Haida myth and legend, crowded into a jade-
coloured canoe and paddling toward an unnamed destination.
The nature of their myth-time voyage is not revealed here,
although we know it is an important one, given the ceremo-
nial regalia of the Chief standing at the canoe's centre. His
splendid hat and Chilkat robe, his speaker's staff and stately
bearing, all announce the significance of this journey.

Something of moment is happening, too, in this unlikely
gathering of so many ancient and eminent creatures and
beings—not that their age and eminence seem to grant them
much peace. The vessel can scarcely contain their biting and
flapping, their clawing and snapping, their wrangling over
power and privilege. The Wolf digs his hind claws into the
back of the Beaver—a crest animal of the Haida and a symbol
of wealth, but also a symbol of colonial Canada—and curls
around from port to starboard to paddle the canoe and bite
the Eagle. The Eagle in turn bites the Bear, who is also licked
by the low-crouching, goggly-eyed Frog, an agent of magical
exchange and transformation. The Bear sits in the bow of this

great canoe with his back to the future but not to his age-old adversary in the stern, the Raven. The Raven, who can don many shapes and faces, many attributes and characteristics, is both trickster and culture hero, greedy and beneficent, and he features prominently in Haida creation myths. It was the Raven who brought light, land and fire to the world, and discovered humankind in a clam shell.

Because he was once painfully deceived by the Raven, the Bear seems wary of the direction in which this devious bird might steer the vessel. The others seem strangely oblivious. Behind and facing the Bear sits his beautiful human mate, the Bear Mother. In Reid's unusual depiction, she has no breasts with which to suckle her children, but she does wear a labret to signify her gender and her high social standing. As her two cubs cling, one to either parent, she paddles firmly forward—although looking in a quite different direction from the Chief and the other male members of his entourage. Behind her and the large-incisored Beaver is the Dogfish Woman who, with her shark headdress, gill-slitted cheeks, vertical pupils, and the hooked nose of a spawning salmon, is perhaps the most enigmatic of the paddlers here. An image again of transformation, she can slip like the Frog between the realms of earth and sea. Like the Bear Mother, she has no breasts and looks into a distance not seen by the male beings. Then there is the tiny Mouse Woman, the Raven's wise and ancient grandmother, peering out from under his sheltering wing and tail. The women in this canoe have their own ideas about where they are going but, like the others, they co-operate in the sculpture's linked metaphors, myths and crests, its allegories of animal-human transmutation and interconnection, its symbolic embrace of land, sea and sky.

Near the stern on the starboard side of the canoe is a small human figure, dubbed by its creator "The Ancient Reluctant Conscript." He is wielding a paddle and wearing a plain

cedar-bark cape and an equally plain hat of woven spruce root. He is wearing, too, a look that mixes resignation with inscrutability: he will paddle but he will not yield up his secrets to his fellow travellers, nor to the raiders who have carried him off from his native village and pressed him into slavery. His features are those of the artist who created him, but it is a modest self-portrait. Bill Reid, far from being a lowly slave, is a much honoured elder, a venerable leader and orator in the great tribe of twentieth-century artists.

The name that Reid has given this character is a reference to "Old Timers", a poem by Carl Sandburg which begins and ends with the line, "I am an ancient reluctant conscript." This identification with a poem from modern Western literature, the casting of the dugout canoe in bronze rather than its carving in wood, its placement in the middle of a busy international airport terminal, the posing of the artist's small self-portrait amongst the oversize creatures and personages of indigenous Northwest Coast myth and legend, the allusions to the classical art forms and styles of those same indigenous peoples, all suggest the widely different histories and cultures, traditions and innovations that Reid has compressed into his art—and his life.

Born in Victoria, British Columbia, in 1920, Bill Reid is the son of an American-born father of Scottish and German origin, and a Haida-born mother from the village of Skidegate. Skidegate is located at the southeastern end of the largest of a group of islands separated from the northern B.C. coast by Hecate Strait. Named the Queen Charlotte Islands in 1787 by the captain of a British merchant vessel, they are known to the native inhabitants of the place as Haida Gwaii, the Islands of the People. At the time of white contact, the Haida people numbered some six to eight thousand and boasted a highly evolved material and ceremonial culture. They were recognized as great canoe makers and carvers,

keen traders, fierce fighters and long-distance voyagers. Like the other indigenous peoples of the Northwest Coast, they lived in large, cedar-plank houses in settled, winter villages; harvested the richly stocked seas, shores and forests; worked wood brilliantly; staged elaborate winter ceremonials; and developed sophisticated oral and visual traditions that described their place within the cosmos.

The historic art of the Haida, closely allied by form and style to the art of other northern Northwest Coast groups like the Tlingit and the Tsimshian, made visible social and religious systems through representations of the creatures, elements and beings of a nature-based mythology. While some art served shamanic purposes, much of it recorded the origin stories of moieties, clans and families, and symbolized the inherited properties and privileges of groups and individuals. These symbols or crests—like the Eagle, the Wolf and the Bear—were carved and painted on everything from house frontal poles of towering red cedar to tiny implements and ornaments of horn and bone. Initially, the wealth, tools and materials gained through trade with whites stimulated the Haida and other Northwest Coast cultures, which reached a florescence around the mid-nineteenth century. The Haida particularly responded to the white demand for "curios" by carving small works and miniature poles in argillite (a soft, black shale found only in Haida Gwaii) and making jewellery in silver and gold. By the end of the nineteenth century, however, the Haida had been decimated by disease, especially smallpox, their numbers dropping by almost 95 per cent. Many aspects of Haida culture were badly eroded by depopulation, government policies and missionizing, and much art-making was discouraged or abandoned.

All this, Reid would learn as an adult. As a child, he fully identified with the anglo-Canadian culture in which he was being raised, and into which his mother had been assimilated.

In the 1940s, however, he began searching out his Haida roots in his mother's home village and later made repeated visits there and to other sites on Haida Gwaii. In the 1950s, while working as a radio broadcaster and taking courses in European jewellery making in Toronto, he taught himself Haida art forms and styles by studying and copying historic examples in museums and private collections. And he discovered a particular affinity for the gold, silver and argillite works of his great-great-uncle, Charles Edenshaw, the most famous Haida artist of the late nineteenth century. Reid's careful analyses of northern Northwest Coast art forms and design conventions and his readings of ethnographic literature coincided with a growing interest in native art and culture amongst white academics, curators and collectors, and a growing sense of pride and cultural reclamation amongst young native artists. His art achieved both critical and popular success in the vanguard of this cultural resurgence.

Despite the debilitating effects of Parkinson's disease, Reid has completed a number of large-scale public commissions, including monumental sculptures in red and yellow cedar and in cast bronze, as well as creating more intimate works in boxwood, yew, gold and silver. In 1985, he was commissioned to produce a sculpture for the chancery of the new Canadian embassy in Washington, D.C. Inspired by nineteenth-century argillite carvings of miniature canoes thronging with animal and human passengers, as well as by his own recent experience producing a suite of full-size, dugout canoes in cedar, Reid began to construct a clay model—a kind of three-dimensional working drawing—of *The Spirit of Haida Gwaii* in his Vancouver studio in the spring of 1986. That same spring, photographer Ulli Steltzer dropped by to visit Reid and was so excited by his new project that she began recording its progress.

Steltzer had known Reid since the early 1970s, when she

moved to Vancouver and began work on her book of photographs and interviews, *Indian Artists at Work*. The German-born daughter of art historians, Steltzer launched herself on a photographic career in New York and New Jersey in the 1950s. She has travelled widely and her portrait subjects have ranged from Princeton intellectuals to new immigrants in California, and from the Inuit of the Canadian Arctic to health workers in the Guatemalan Highlands. Her camera, however, seems to have a special affinity for the native artists of the Northwest Coast. Deep respect for her subjects is expressed everywhere in her work.

Steltzer followed *The Spirit of Haida Gwaii* from its inception in clay through its transformation to a full-scale plaster pattern, built over an armature of steel rod and mesh. She also documented the pattern's shipment to the Tallix Foundry in Beacon, New York; the making of a polyurethane rubber mould there and the casting of a wax master; the dipping of the wax master in silica slurry and sand to create a hard ceramic shell; and the pouring of the molten bronze. Because of its creative relationship to historic argillite carvings, the first casting of *The Spirit of Haida Gwaii* was given a glossy black patina. Subtitled *The Black Canoe*, it was installed in Washington in 1991.

A second bronze casting, patinated in blue-green to evoke the naturally occurring jade of British Columbia and subtitled *The Jade Canoe*, was completed in 1994, purchased by the Vancouver International Airport Authority, and placed on the Departures Level of the new International Terminal Building in the spring of 1996. It floats there now, a vessel crowded with Haida tales and traditions, silently speaking to travellers from many other tribes, travellers on this other crowded vessel, this blue-green canoe, the planet Earth.

THE

PHOTOGRAPHS

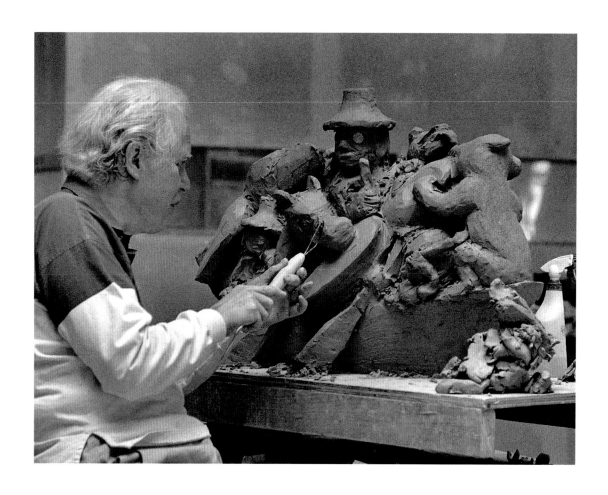

Bill Reid in his Vancouver studio on Granville Island, working on the clay model of the sculpture, then jokingly called *Ship of Fools*.
JUNE & JULY 1986

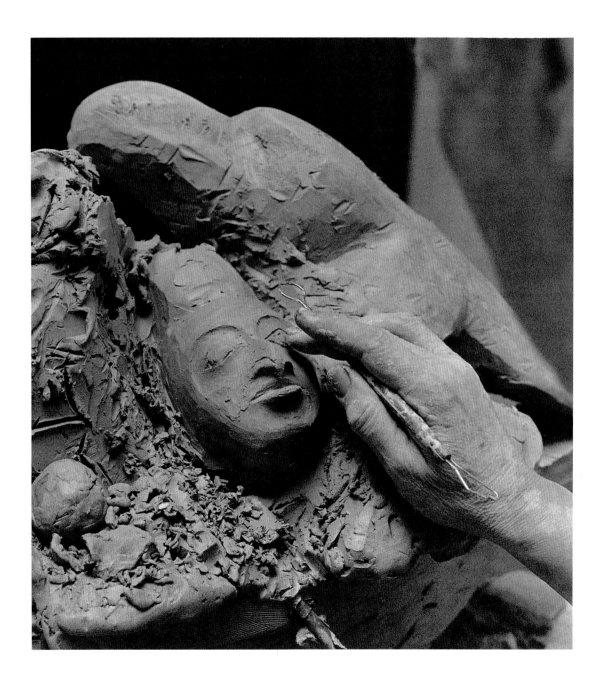

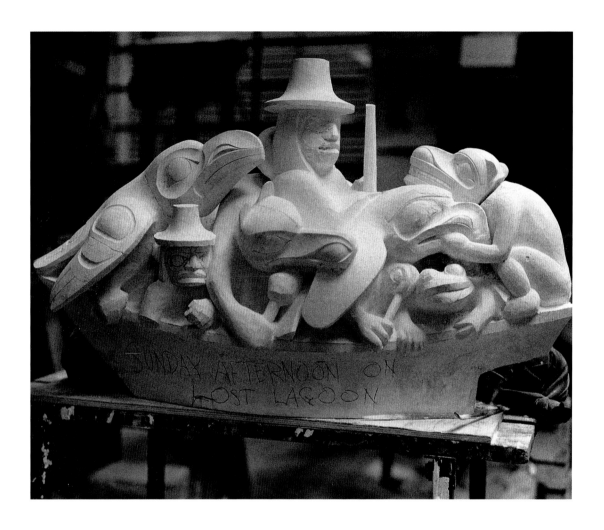

The plaster cast of the clay model. Bill Reid wrote "Sunday afternoon on Lost Lagoon" on the hull in reference to childhood memories of Sunday afternoon drives in the family station wagon with the kids squabbling in the back and his father steering straight ahead. OCTOBER 1986
*Facing page:* Replacing the plaster cast of the Bear Mother with fresh clay. JANUARY 1987

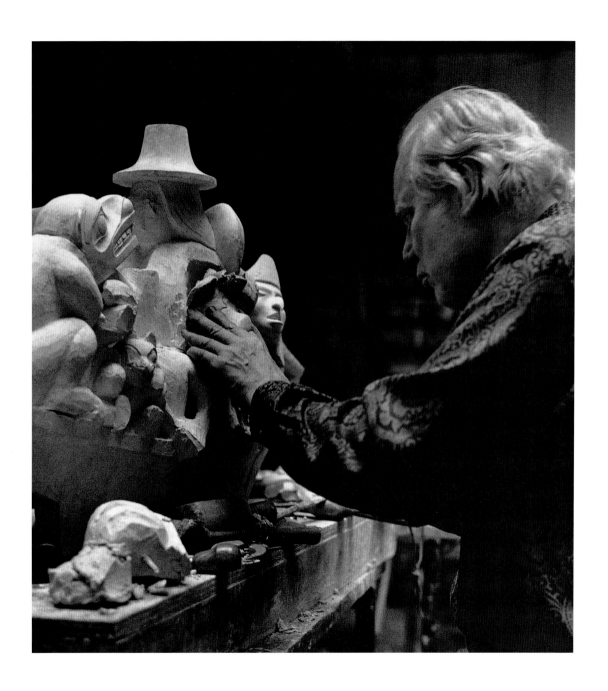

Bill Reid talking with artist George Rammell by the full-size 6-metre prototype, made by placing clay on an armature of metal rods and mesh. Rammell is the mastermind who designed the complex structure so that the figures could be removed one by one for the next stage. FEBRUARY 1988

*Facing page:* The Bear family, the Chief and the Beaver in the full-size clay prototype of the canoe, which is nearing completion with all the figures on board. APRIL 1988

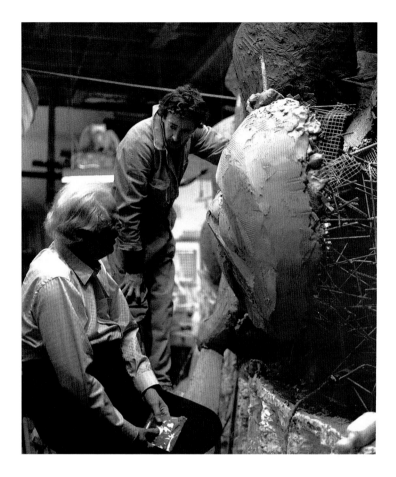

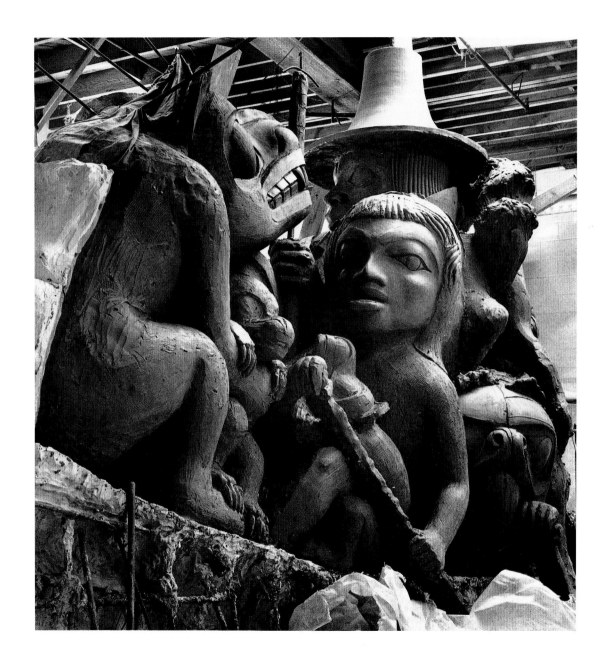

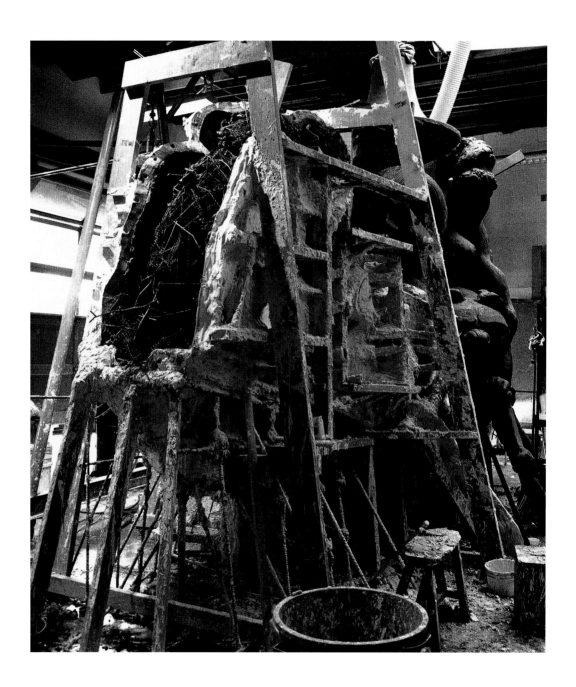

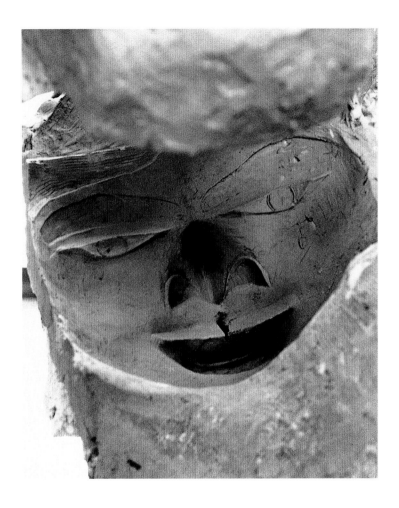

*Left:* The entire Bear family has been removed from the canoe to be transformed into plaster. APRIL 1988

*Above:* A negative image of the Dogfish Woman's face, waiting to be cast into plaster. MAY 1988

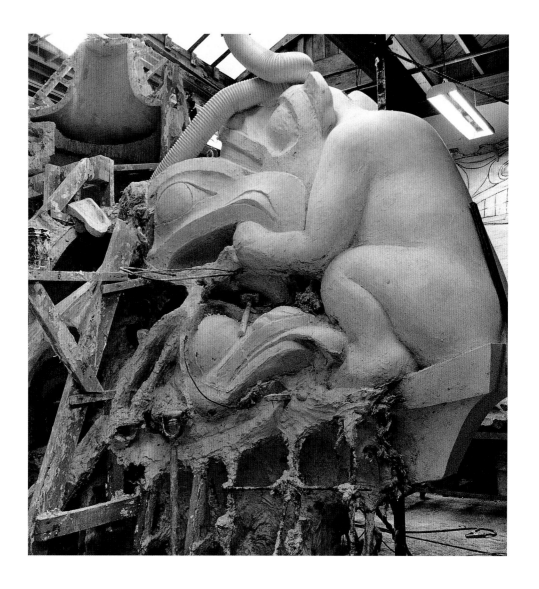

The Bear Father, the Eagle's head and the Frog, now transformed into plaster, have been returned to their places in the canoe.

OCTOBER 1988

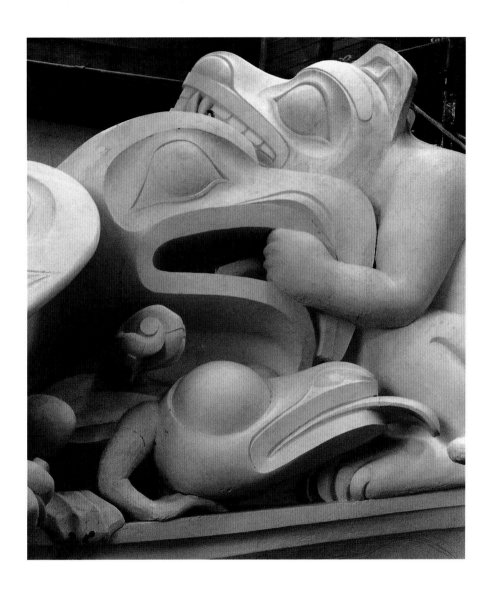

The full-size figures and the canoe
itself continue to be refined.

FEBRUARY 1989

Bill Reid decides to revise the Ancient Reluctant Conscript. He wears a cedar-bark cape to pose for the figure, who looks a lot like him. MARCH 1989

*Facing page:* George Rammell laying down some plaster for the cape of the Ancient Reluctant Conscript. APRIL 1989

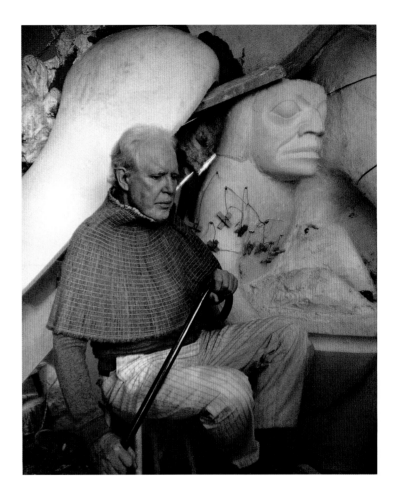

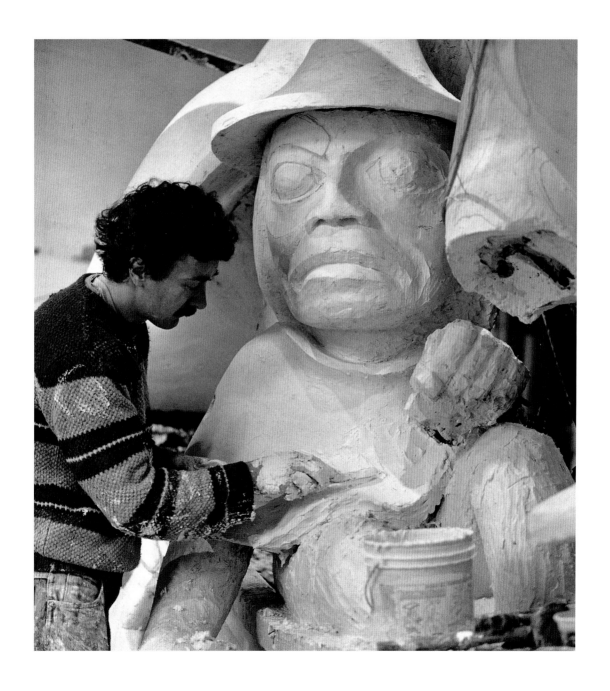

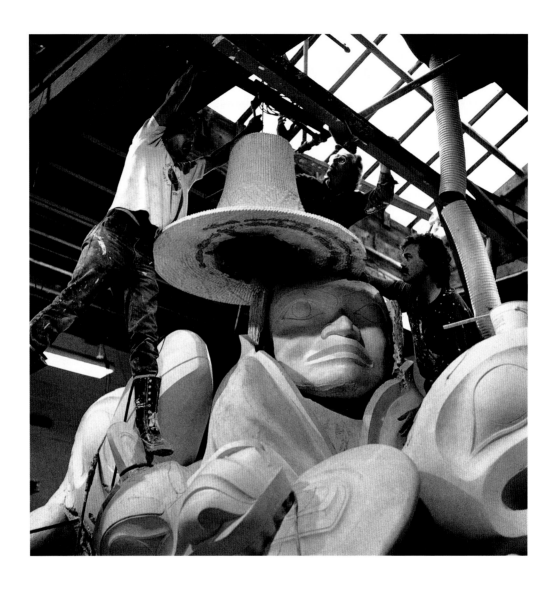

Manoeuvring the completed
Chief's hat into place are George
Rammell and two other crew
members, James Watt and John
Nutter. APRIL 1989

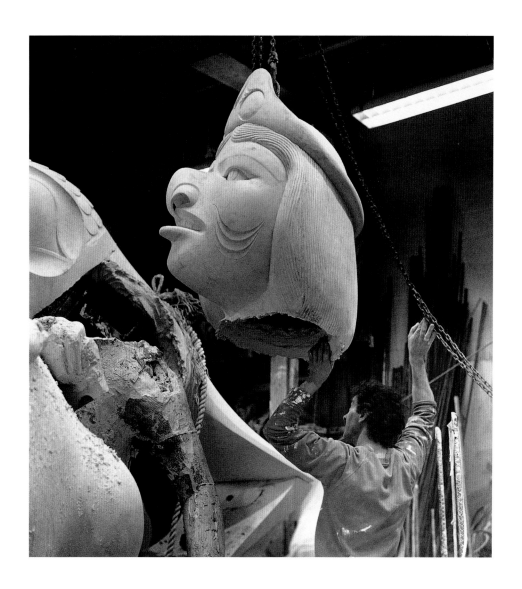

George Rammell guiding the
finished head of the Dogfish
Woman into position. APRIL 1989

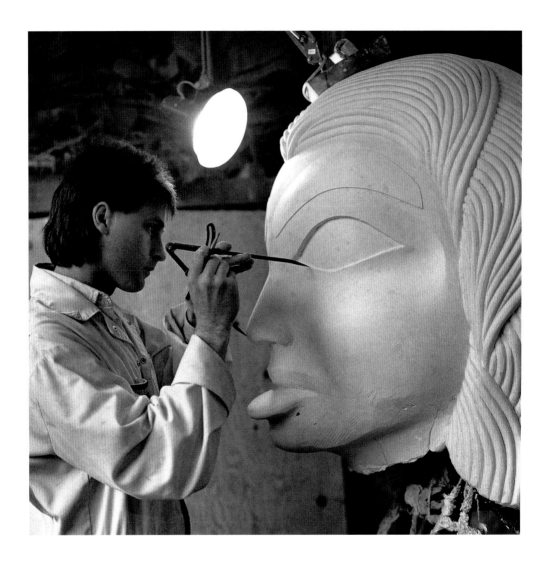

Working on different sections of the plaster pattern, Doug Zilkie checks the proportions of the Bear Mother's face while Nancy Brignall (*facing page*) carves designs into the Chief's cape. MAY 1989

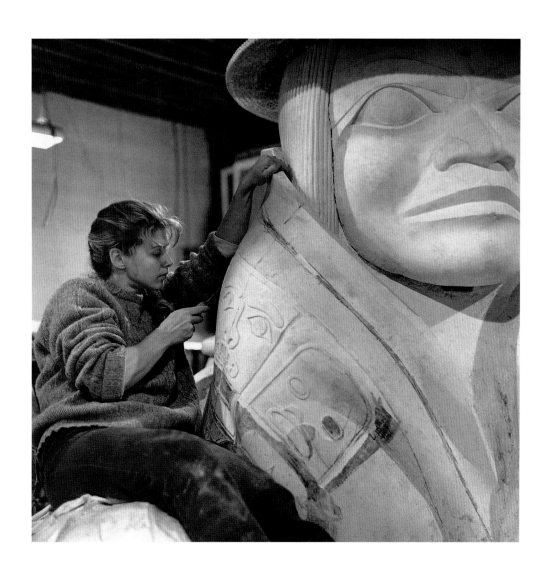

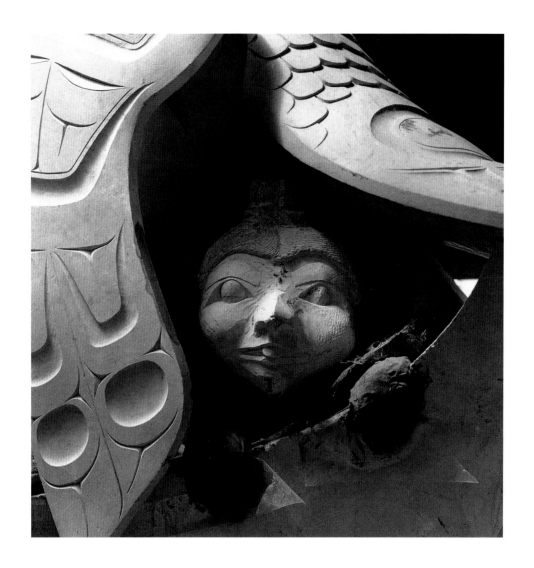

The Raven's wing and tail have taken on their final form, but the Mouse Woman is still in the making. JUNE 1989

*Facing page:* The Mouse Woman has crawled out of the canoe: she has a head and arms but still lacks a body and feet. AUGUST 1989

34

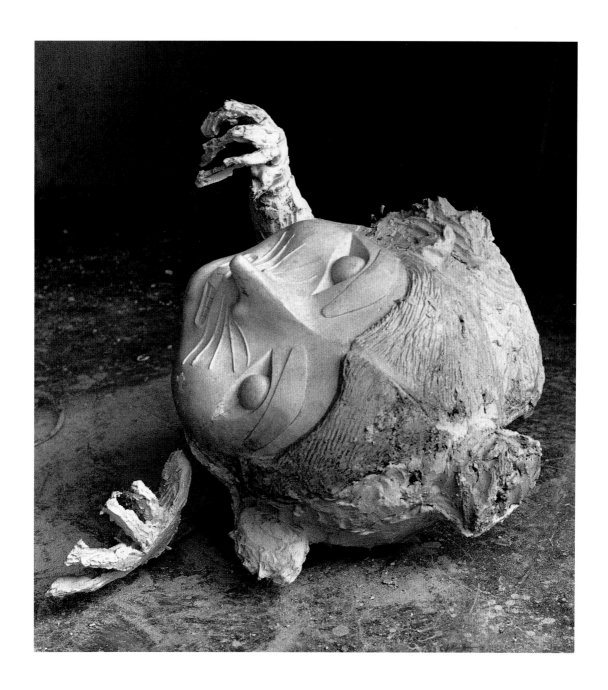

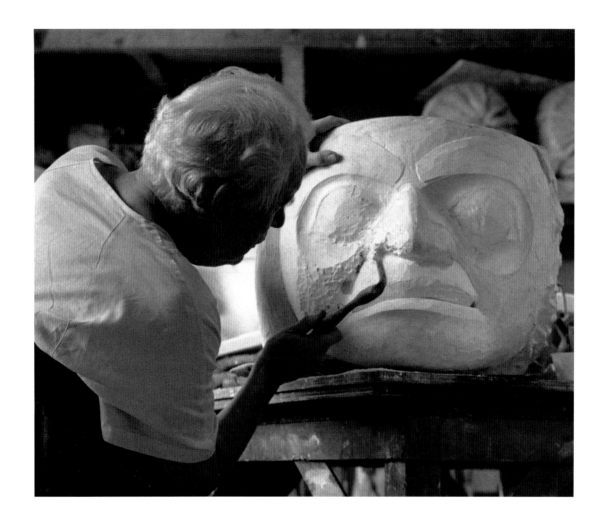

Bill Reid is still reworking the Ancient Reluctant Conscript while other parts of the sculpture like the Dogfish Woman (*facing page*) are finished. JULY & AUGUST 1989

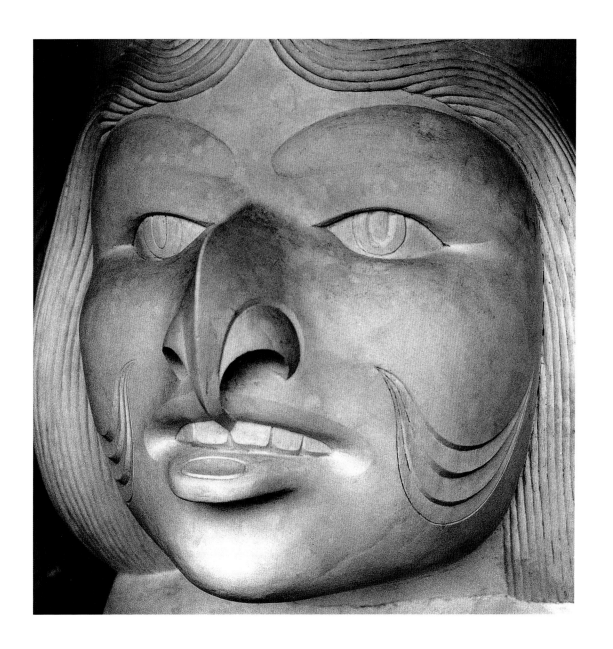

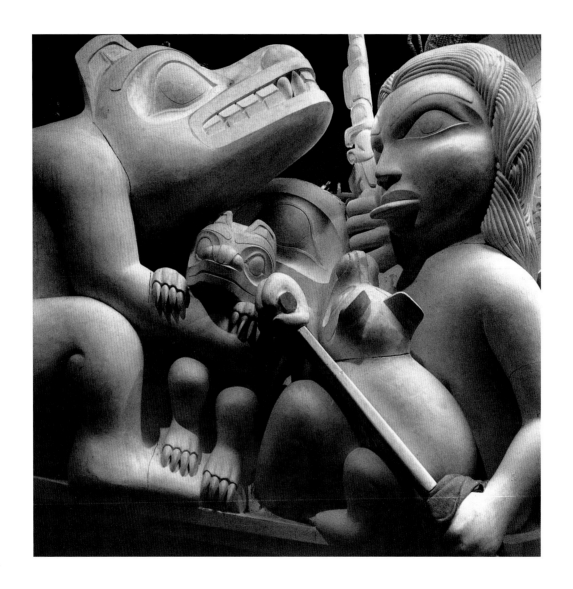

The finished plaster pattern of the Bear Father, Good Cub, Bad Cub and Bear Mother. The join marks where they have been reattached are still visible. JULY 1989

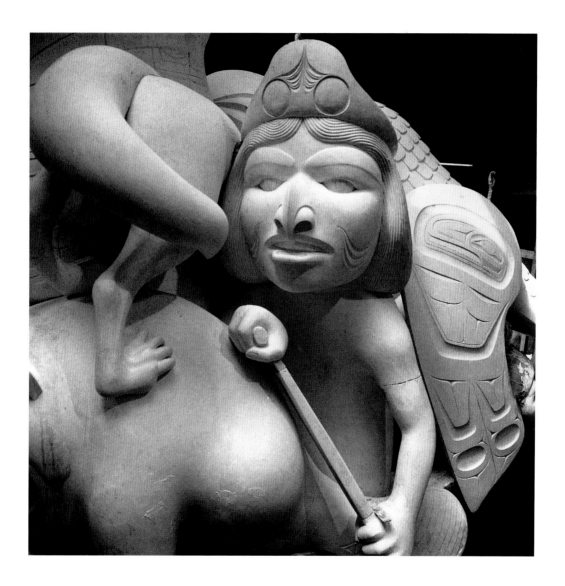

The Wolf, his tail not yet textured, stands on the Beaver, while the Dogfish Woman paddles in front of the Raven's wing. JULY 1989

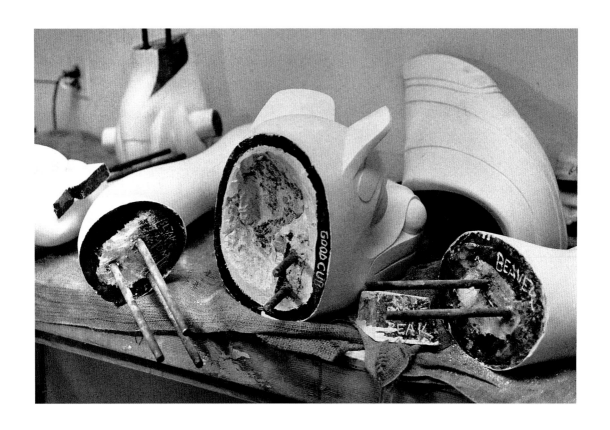

Sections of the plaster pattern dismantled, marked and ready to be crated for shipment to the Tallix Foundry in New York state.
AUGUST 1989

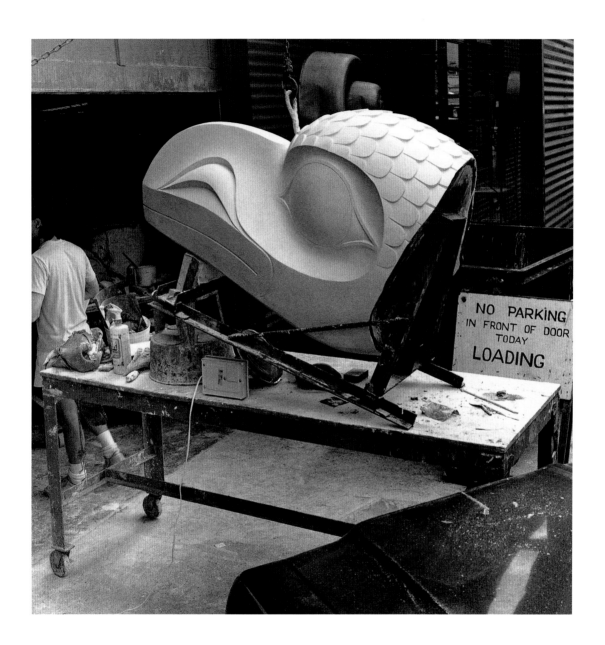

NO PARKING
IN FRONT OF DOOR
TODAY
LOADING

Artist Don Yeomans was commissioned to carve the pattern for the Chief's talking stick out of yellow cedar. APRIL 1990

*Facing page:* Bill Reid is working on the Killer Whale to be placed on top of the talking stick. The rest of the sculpture has already been shipped to the foundry. MAY 1990

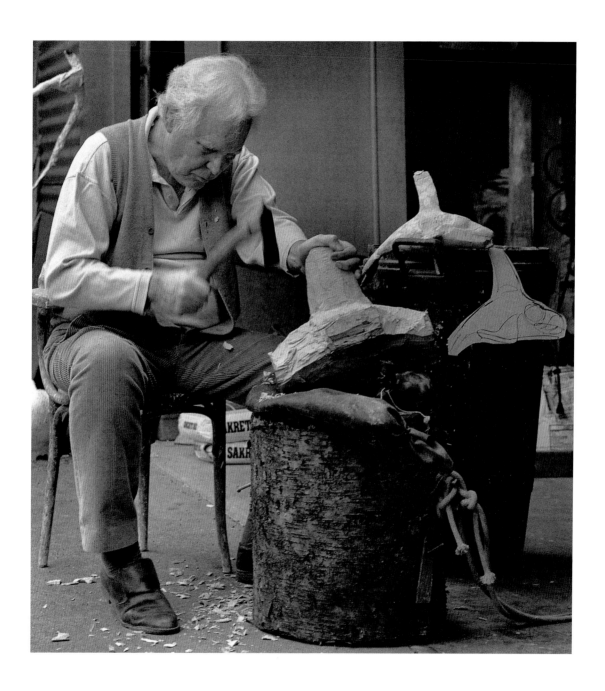

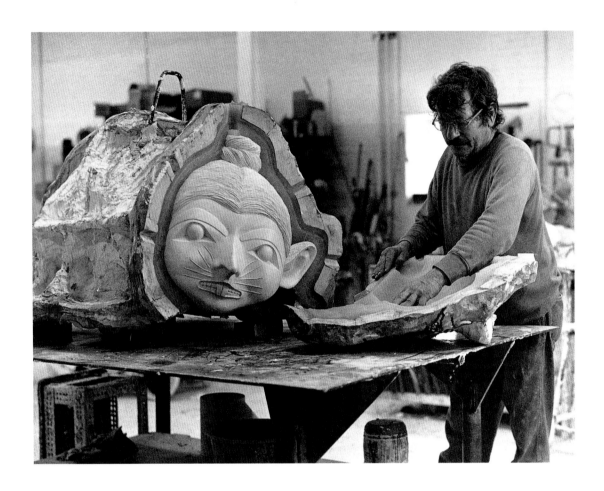

At the foundry, Gerhard Gunter frees the plaster pattern of the Mouse Woman from its rubber mould and casing. Many layers of wax are applied to the rubber moulds to make wax patterns. *Facing page:* David Hyman and Kathy Wood peel away the rubber mould from the wax pattern of the Raven's head. MAY 1990

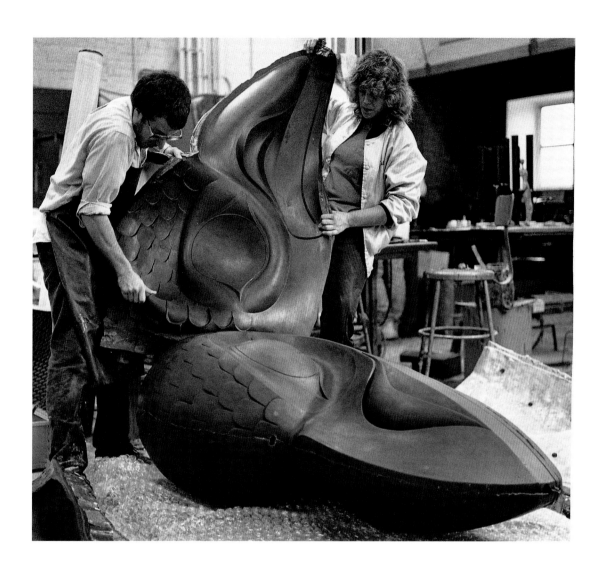

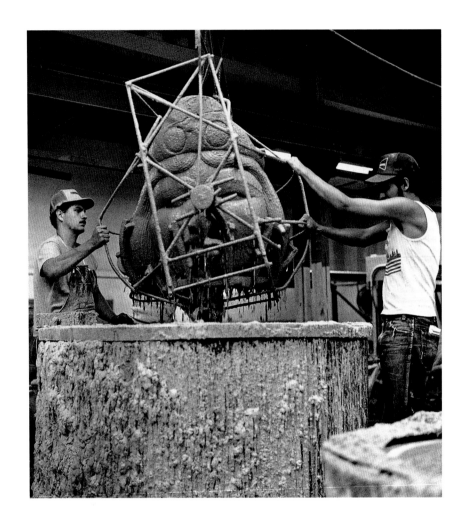

The wax pattern of the Dogfish Woman's head emerges from a slurry and next will get a covering of silica sand. This process is repeated until the coating reaches the desired thickness both inside and outside. It will then be fired to release the wax and become a ceramic shell. The wax pattern of the Bad Cub (*facing page*) is waiting for its turn in the slurry. AUGUST 1990

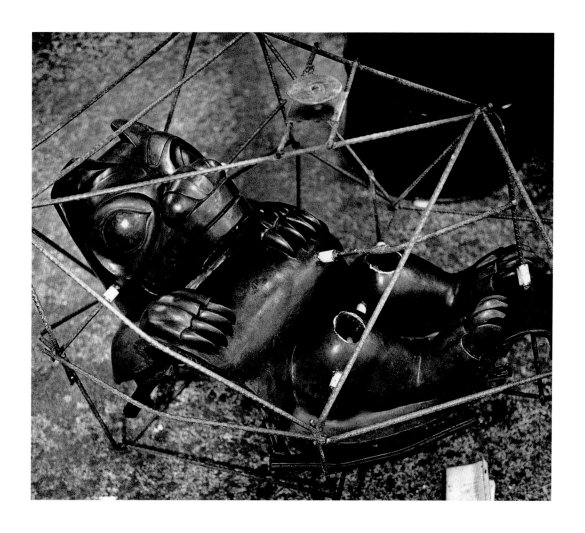

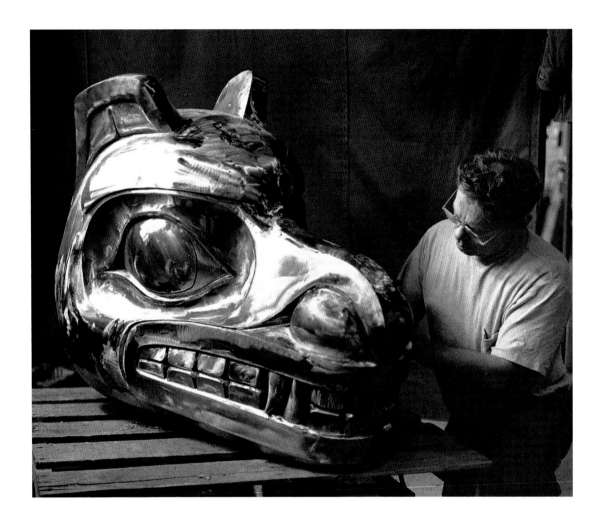

In another part of the foundry, molten metal is poured into the cavity of the ceramic shells. Ray Montadari cleans up the bronze cast of the Bear Father's head. AUGUST 1990

*Facing page:* One by one, the bronze figures re-enter the canoe; the wing of the Raven remains to be attached. The sculpture is not yet patinated. JANUARY 1991

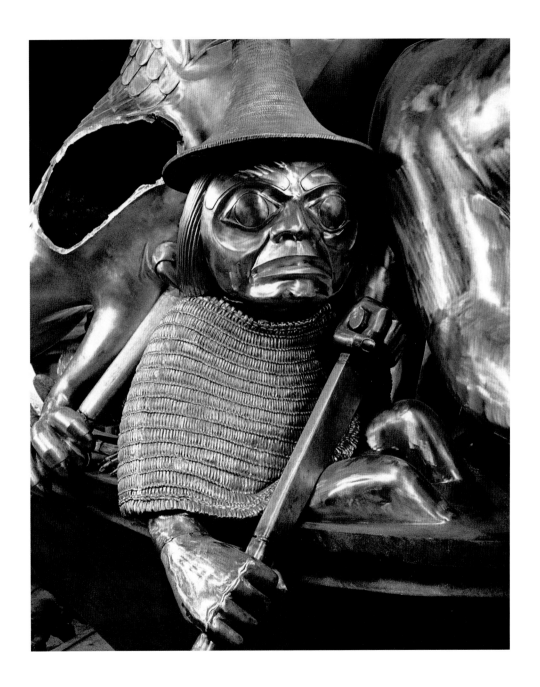

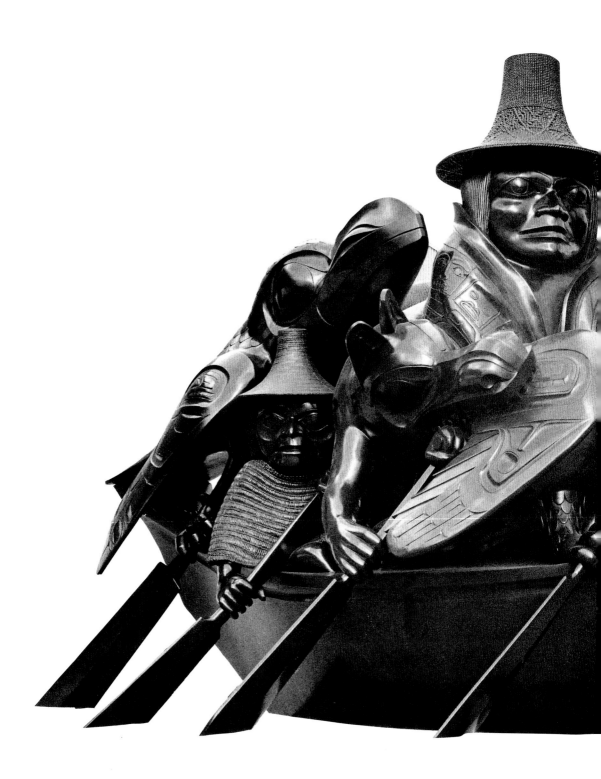

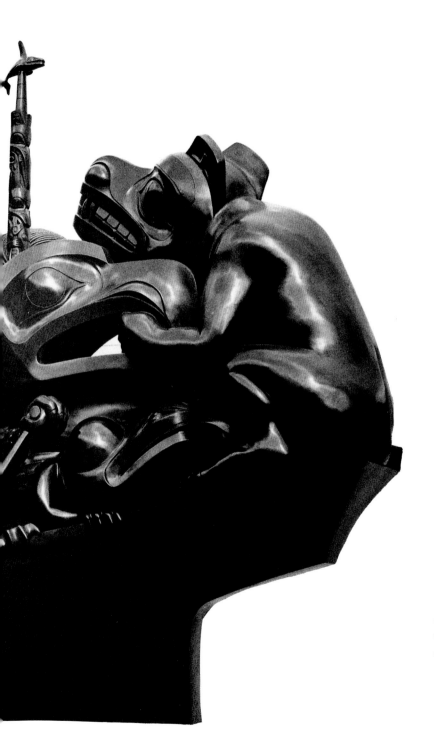

*Pages 50/51 and 52/53:* The completed and patinated bronze cast, shown from both sides.

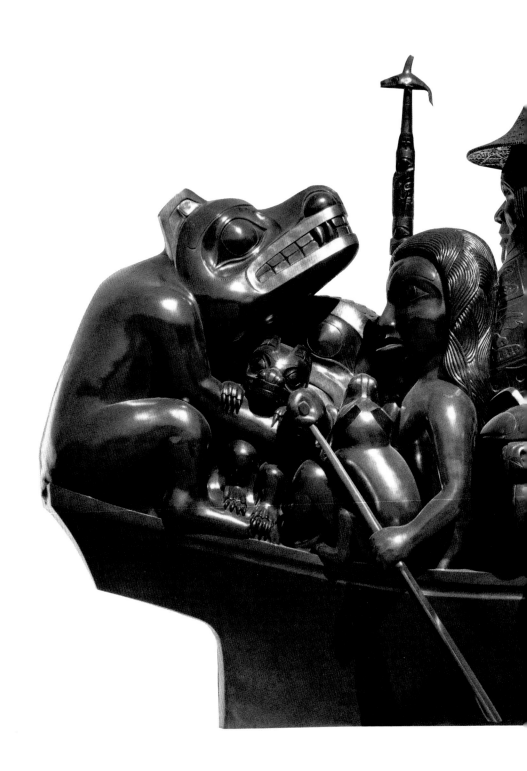

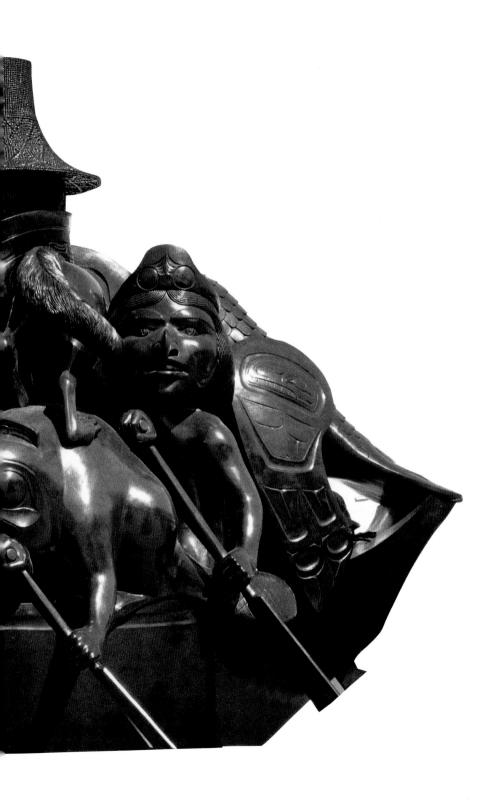

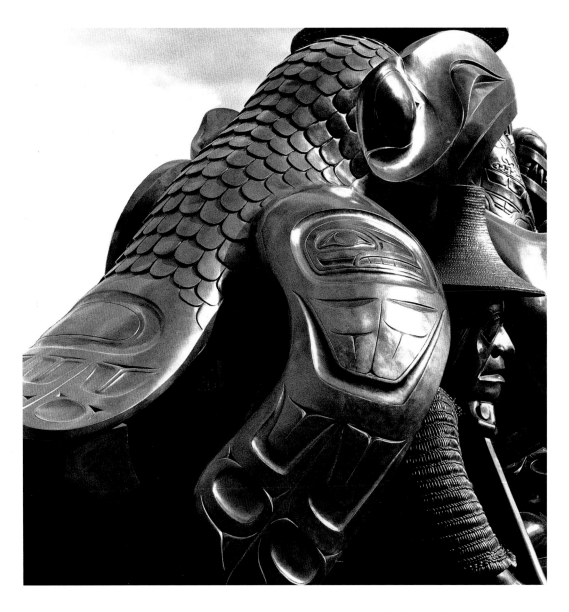

The Raven, the steersman of
the canoe.

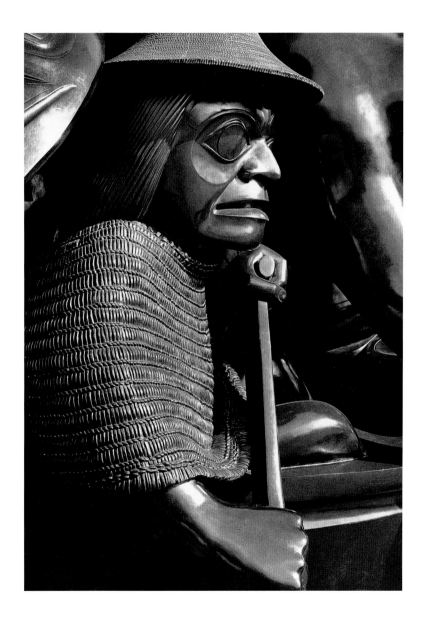

The Ancient Reluctant Conscript
in his cedar-bark cape.

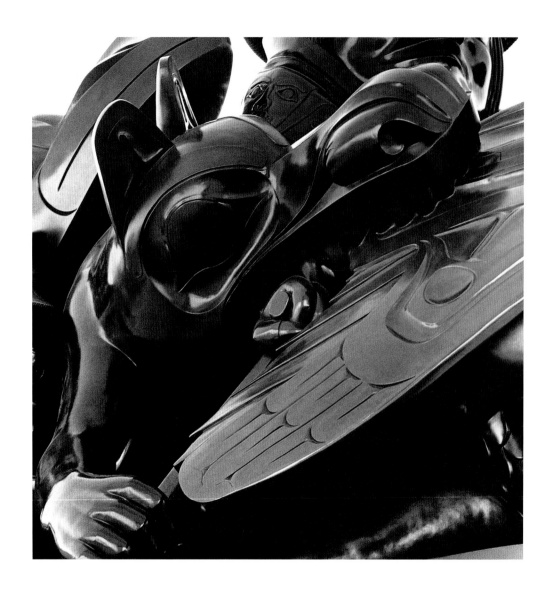

The Wolf gnawing the Eagle's wing.

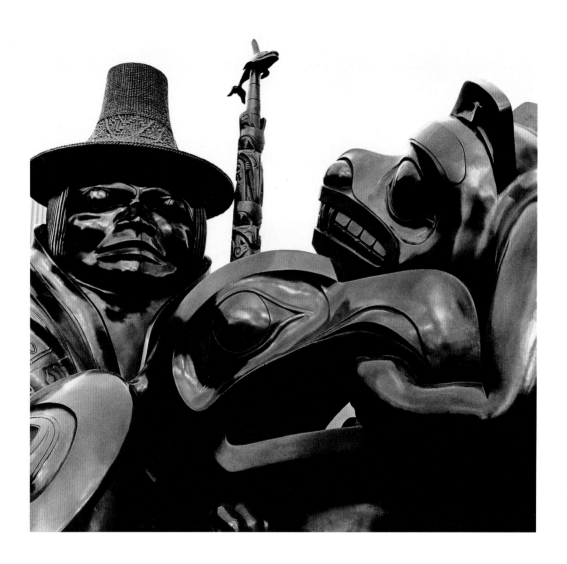

The Chief holds his talking stick
while the Eagle bites the Bear
Father's paw.

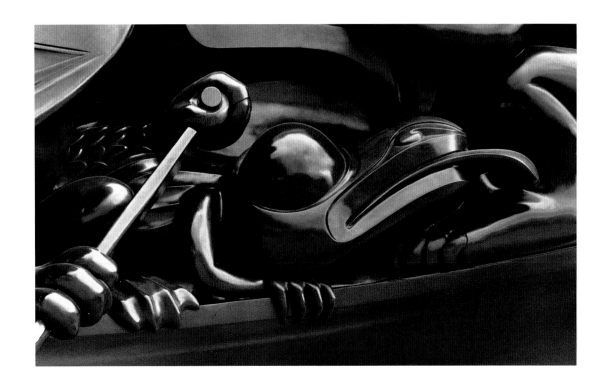

The Frog crouches below the Eagle's paddle and holds onto the side of the canoe.
*Facing page:* The whole Bear family: Father, Bad Cub, Good Cub and Mother.

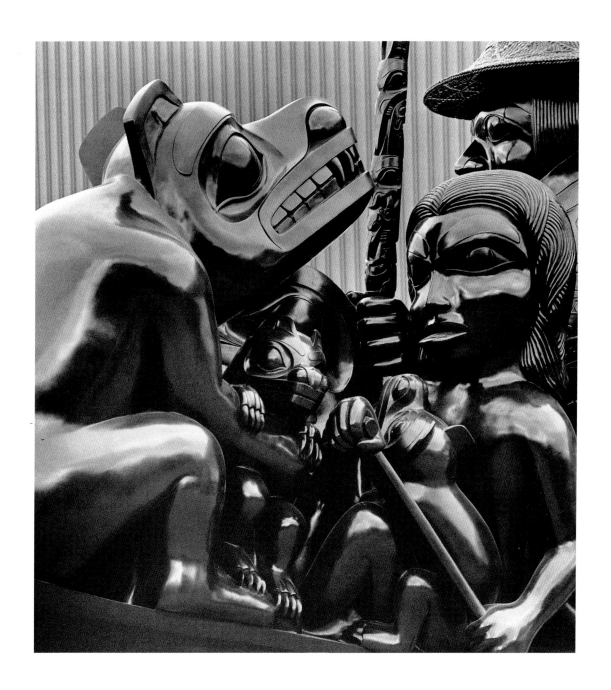

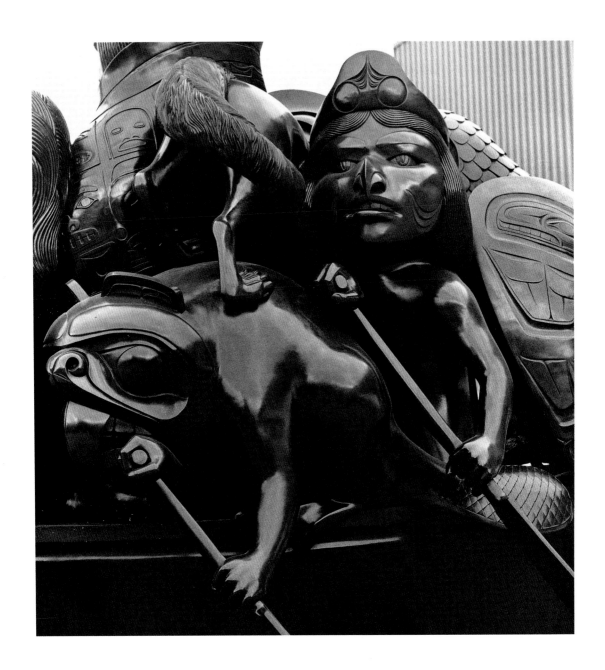

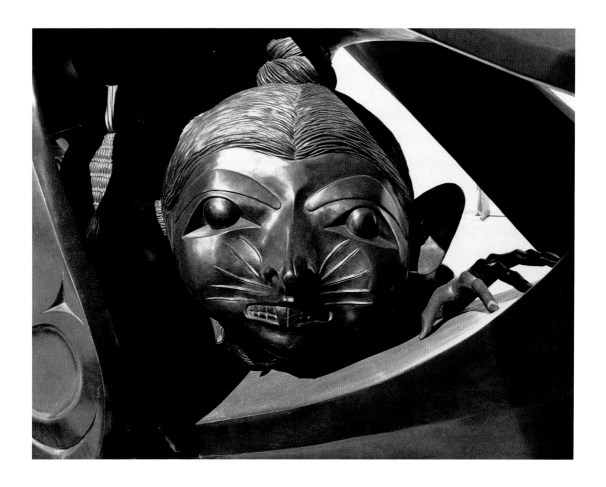

*Facing page:* The Beaver, with the Wolf standing on his back, as the Dogfish Woman paddles.

The Mouse Woman in the shelter of the Raven's wing.

# The Spirit of Haida Gwaii

## The Jade Canoe

### by Bill Reid

*Bronze cast with jade green patina, second of two castings*
*6.05 m (19'10") long, 3.89 (12'9") high, 3.48 m (11'5") wide*

ORIGINALLY CONCEIVED and created for the new Canadian Embassy in Washington, D.C., the sculpture was first created in 1986 as a ⅙-scale clay maquette. It was enlarged to a full-scale clay model in 1988. In 1989 a mould was taken from the full-scale model and the sculpture was cast in plaster for further refinement. Later that year, the plaster pattern was completed and sent to the Tallix Foundry in New York state. The first bronze casting was completed in 1991 and was donated to Her Majesty the Queen in Right of Canada (the Government of Canada) by Nabisco Brands Ltd., Toronto, Canada. It was put on display November 1991 at the Canadian Embassy in Washington, D.C., and is titled *Spirit of Haida Gwaii, the Black Canoe*.

A second and final casting, titled *Spirit of Haida Gwaii, the Jade Canoe*, was commissioned by the Vancouver International Airport Authority in 1993. It was completed at the Tallix Foundry under the supervision of Bill Reid and installed at the airport on the 18th of April 1996 to welcome visitors from around the world.